HEREFORD

HISTORY TOUR

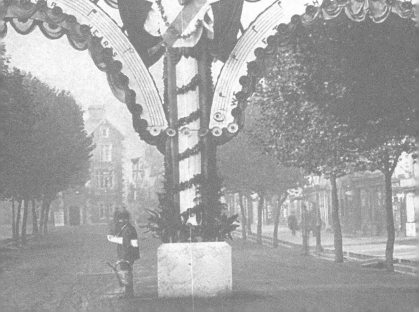

Map contains Ordnance Survey data © Crown copyright and database right [2014]

First published 2015

Amberley Publishing
The Hill, Stroud,
Gloucestershire, GL5 4EP
www.amberley-books.com

Copyright © Derek Foxton, 2015

The right of Derek Foxton to be
identified as the Author of this work
has been asserted in accordance with
the Copyrights, Designs and Patents
Act 1988.

ISBN 978 1 4456 4629 9 (print)
ISBN 978 1 4456 4630 5 (ebook)

British Library Cataloguing in
Publication Data.
A catalogue record for this book is
available from the British Library.

Typesetting by Amberley Publishing.
Printed in Great Britain.

INTRODUCTION

Hereford is full of history and has a changing face that remains largely unrecorded. During the years 1950–80, when planning laws were very flexible, the city lost many important buildings as developers disregarded much of our heritage and took advantage, demolishing anything they wished. The local authorities were often powerless to prevent such destruction and thus should not always be blamed. Today their powers and conservation area laws will hopefully preserve what is left of our heritage, as well as control future developments. We cannot live in the past and where there are no special reasons to conserve old buildings, we will get new replacements, hopefully with well thought out designs.

WHSmith's shop in High Town contains a well preserved timber-framed building hidden behind a Victorian front. The original developer's proposal was to demolish the timber-framed building but, as customers can now see, it is now an interior feature. In residential areas of the city we often see alterations to houses such as replacement doors and windows. Owners who use materials and designs similar to the original are to be congratulated.

Old picture postcards and photographs of Hereford are a valuable source of information and remind us of our heritage. Some of the original postcards and photographs reproduced are faded sepia prints and, though not ideal for reproduction, are included for their unique historic content.

I hope that this book will be of interest to present-day readers and provide some historical reference for future generations.

ACKNOWLEDGEMENTS

I wish to express my thanks to my wife, Maria, for her patience and help with the editing of this book. When I was in front of my computer I often missed calls for household chores.

I thank the following for help and permission to reproduce their photographs (not in order of merit), some of whom are no longer alive: The Francis Frith Collection; Herefordshire Council; Keith James, Bustin Collection & Hereford Records Office; Angus Jones; The Pubs of Hereford City, Shoesmith & Eisel.

Wherever possible, I have made every effort to obtain copyright permission.

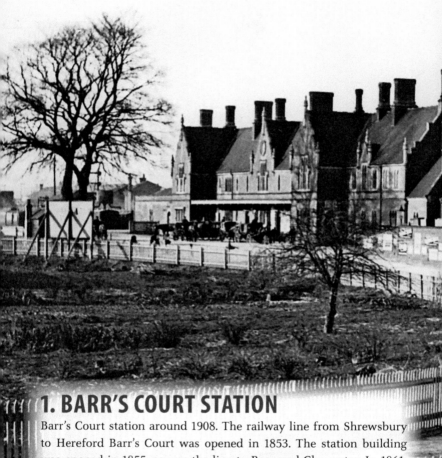

1. BARR'S COURT STATION

Barr's Court station around 1908. The railway line from Shrewsbury to Hereford Barr's Court was opened in 1853. The station building was opened in 1855, as was the line to Ross and Gloucester. In 1861, the line to Worcester was opened while the line to Hay and Brecon opened three years later. By 1893, the station was the centre for all rail travel in Hereford. The station building is listed and awaits tenants in the upper floors of the station.

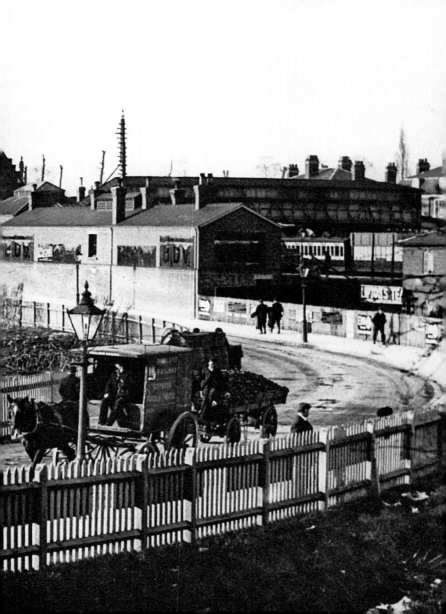

2. BARR'S COURT STATION PLATFORM

The northbound platform in Hereford railway station, taken by Mr Zimmerman in the early 1900s. The very well dressed ladies are just around to board the first class carriage at the platform. Photograph from the late Basil Butcher's collection.

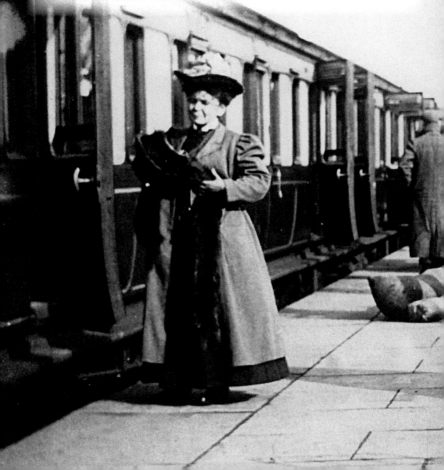

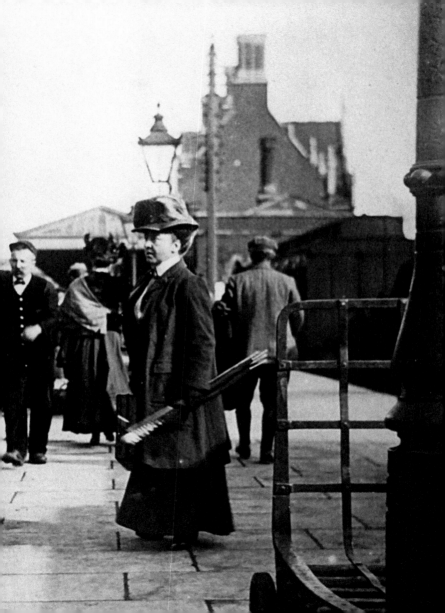

3. BARTON RAILWAY STATION

In the mid-Victorian period, Barton station trains departed for Newport and Abergavenny. Barton station, seen in this picture, was closed to passenger traffic in 1893, following an agreement for the Midland Railway to use Barr's Court. Barton survived for freight use until 1979. Little now remains of the original view except the distant house.

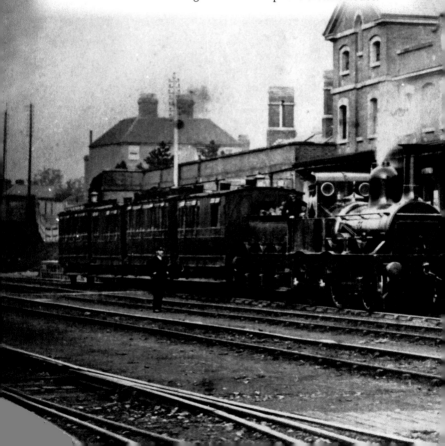

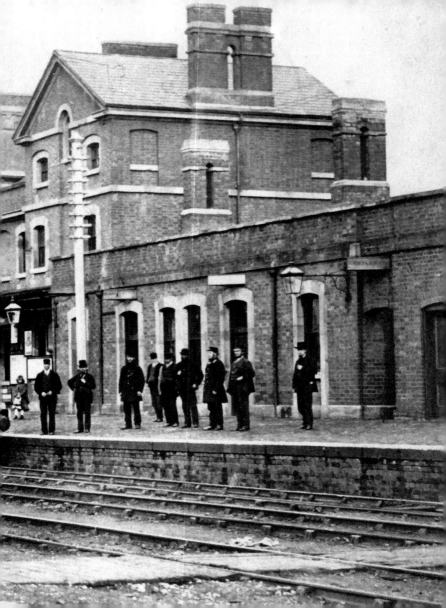

4. PANORAMA OF HEREFORD BUS STATION

This view was taken in 1937 at the 'new' bus station, on the site of the old prison where, in 1895, Joseph Flockton was chief warder and acting prison governor. Before the old gaol was demolished in 1935, local people were invited to inspect the buildings on payment of 6*d*. The former Governor's House was retained and converted into a waiting room and enquiry/booking offices for two major bus companies.

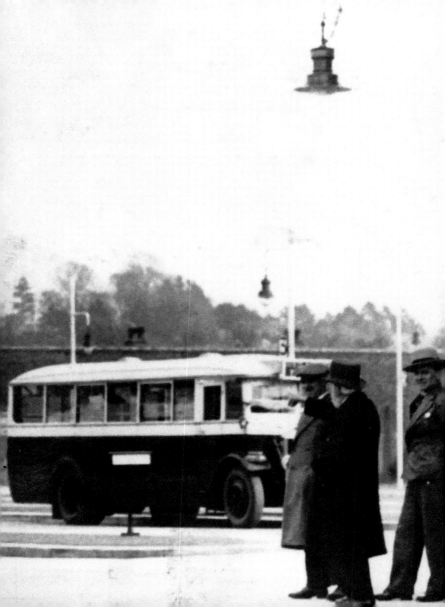

5. H. A. SAUNDERS LTD, COMMERCIAL ROAD

In 1938, H. A. Saunders Ltd purchased this building and opened a garage called Austin House. There is a petrol pump under the archway entrance to the workshops at the rear of the building. There are six cars visible in the showroom with an advert for car radios on the window. Austin being a popular make, there would have been many local people who purchased a car here.

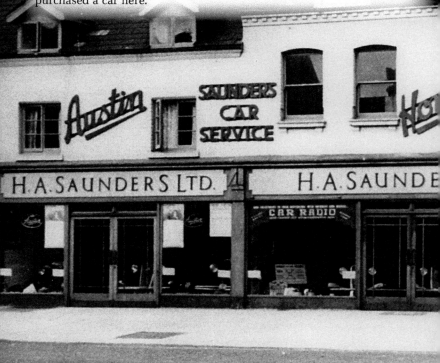

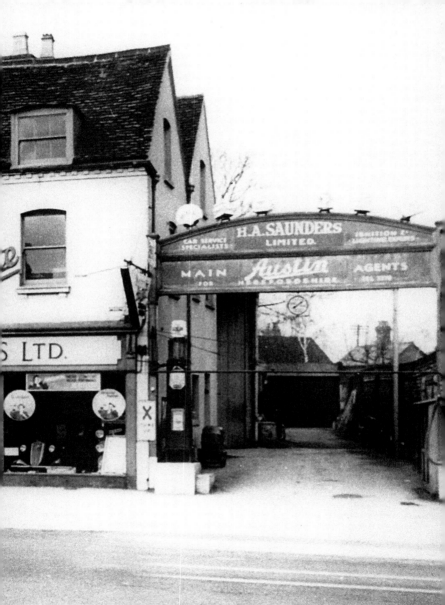

Welcome to the Festival

FESTIVAL DECORATIONS · COMMERCIAL

6. THREE CHOIRS FESTIVAL ARCH, COMMERCIAL ROAD

Commercial Road in September 1906, towards the Kerry Arms Hotel. The huge decorative twin arch built across the road is surmounted by the city coat of arms and was erected for the Hereford Three Choirs Festival. Behind the trees to the left is Greenland's furniture depository, and to the right is the entrance to Monkmoor Street, with the Great Western Inn on the corner.

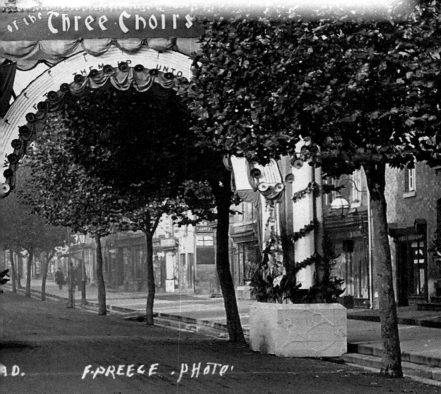

7. PIGOTT'S HERBALIST SHOP, COMMERCIAL ROAD

The treatment of disease with herbs is said to be as old as mankind itself. Here is Mr W. Pigott outside his herbalist's shop (around 1930) in Commercial Road. It was the only one in the county and continued in business until 1960. He was a local character and served as a Labour councillor. He was made alderman in 1947 and mayor in 1949. The window sign reads, 'Herbs positively cure diseases'.

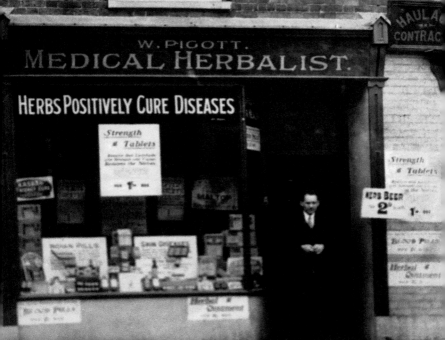

8. THE EYE AND EAR HOSPITAL, COMMERCIAL ROAD

The Herefordshire and South Wales Eye and Ear Institution was established in Commercial Road by the Hon. Surgeon Mr F. W. Lindsay in July 1882. It opened 1 January 1884 as a public institution. The building proved to be too small and unsuitable. In Queen Victoria's Jubilee year, 1887, funds were raised to build a new hospital that opened on 20 August 1889 on Eign Street. The loss of the old hospital has opened up the full frontage of the church to Commercial Road.

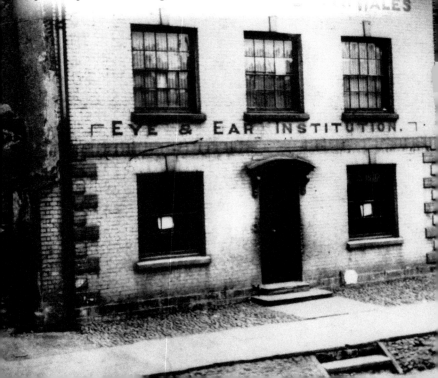

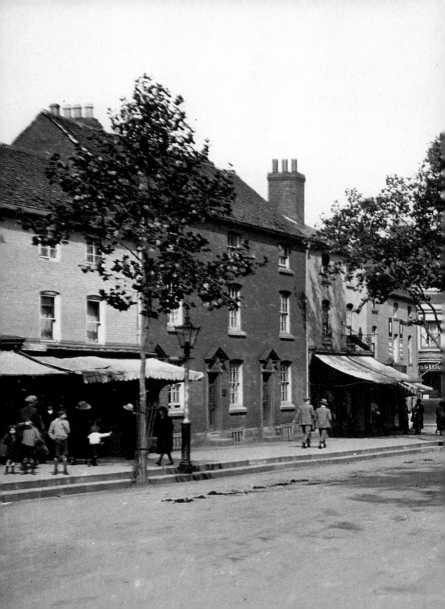

9. COMMERCIAL ROAD, LOOKING NORTH-EAST

Here we are in the middle of Commercial Road looking towards the north-east and the junction with Monkmoor Street. The row of shops included a taxidermist, bicycle agent, a servants' registry and bootmaker. The Great Western Inn is visible on the far side of the road junction. Note the steps up to the pavement. The buildings remain, even if the chimney pots do not.

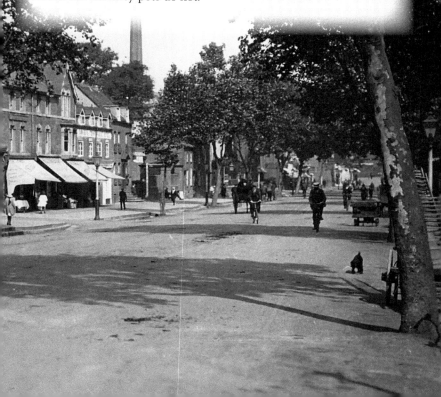

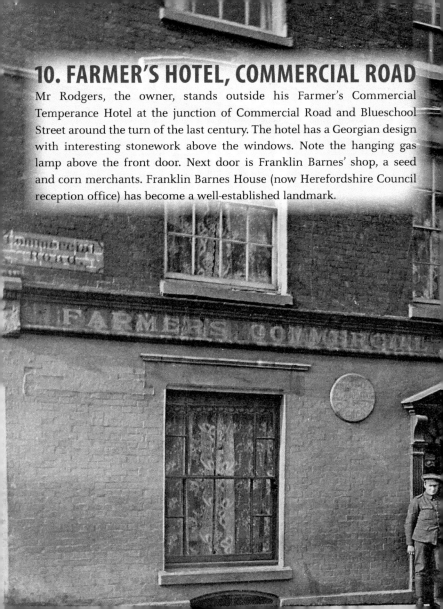

10. FARMER'S HOTEL, COMMERCIAL ROAD

Mr Rodgers, the owner, stands outside his Farmer's Commercial Temperance Hotel at the junction of Commercial Road and Blueschool Street around the turn of the last century. The hotel has a Georgian design with interesting stonework above the windows. Note the hanging gas lamp above the front door. Next door is Franklin Barnes' shop, a seed and corn merchants. Franklin Barnes House (now Herefordshire Council reception office) has become a well-established landmark.

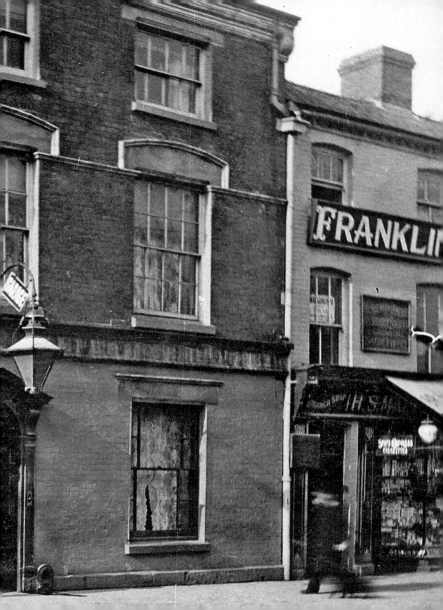

11. BERROW'S HOUSE, BATH STREET

In 1895, this building in Bath Street was described as the 'Industrial Aid Society's Flour Mills' where William Lloyd was secretary and manager. The society was founded by the Revd John Venn, vicar of St Peter's, who helped the poor by letting allotments on nearby land. An invoice for 1902 advertised that they sold flour in free sacks weighing from 140 lbs to 280 lbs. The building is now a business centre.

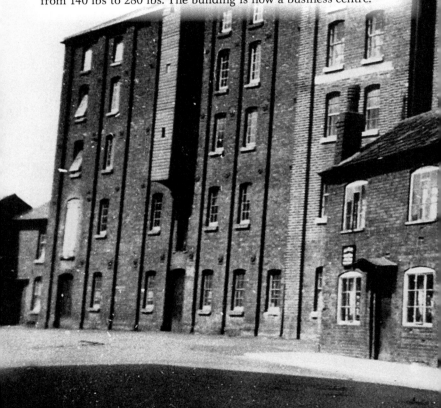

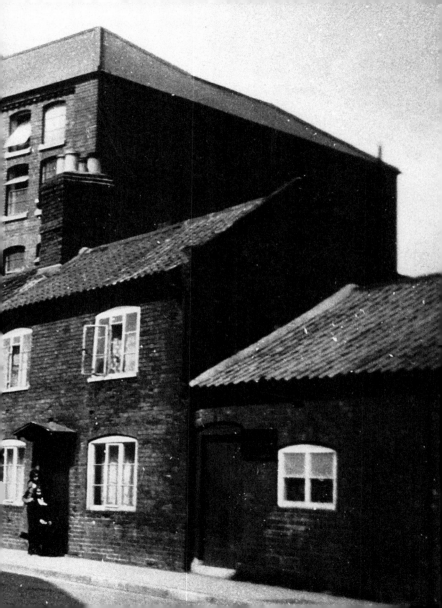

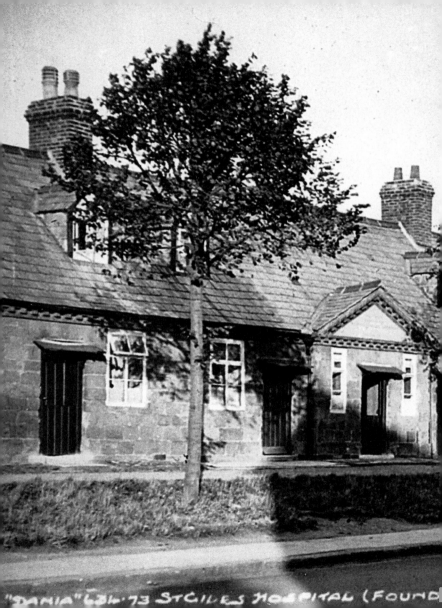

"DANIA" L.B.L. 73 St GILES HOSPITAL (FOUND

12. ALMSHOUSES, ST OWEN STREET

At the junction of the Ledbury Road and St Owen Street on the left are the St Giles' Hospital almshouses, with the chapel protruding out well onto the pavement. Founded around 1290, in 1682 the almshouses were rebuilt using voluntary subscriptions. There are five houses, each with a piece of land. In 1927, the chapel was taken down for road widening and re-erected slightly nearer the city. In 1928, a plaque was placed on the new wall at the road junction that is now hidden by a public bench.

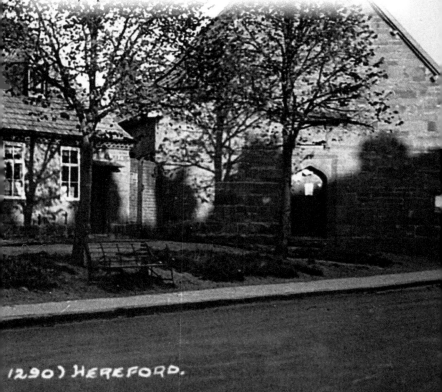

1290) HEREFORD.

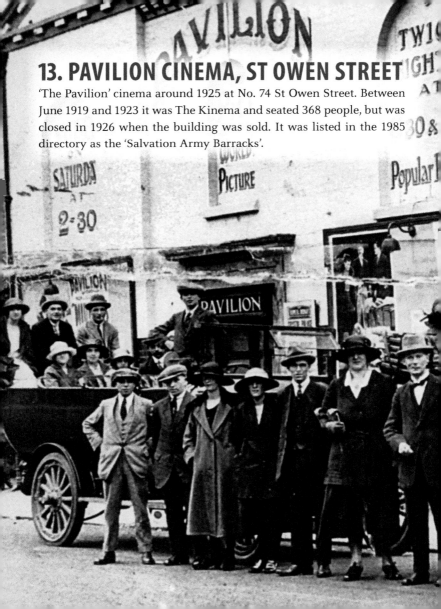

13. PAVILION CINEMA, ST OWEN STREET

'The Pavilion' cinema around 1925 at No. 74 St Owen Street. Between June 1919 and 1923 it was The Kinema and seated 368 people, but was closed in 1926 when the building was sold. It was listed in the 1985 directory as the 'Salvation Army Barracks'.

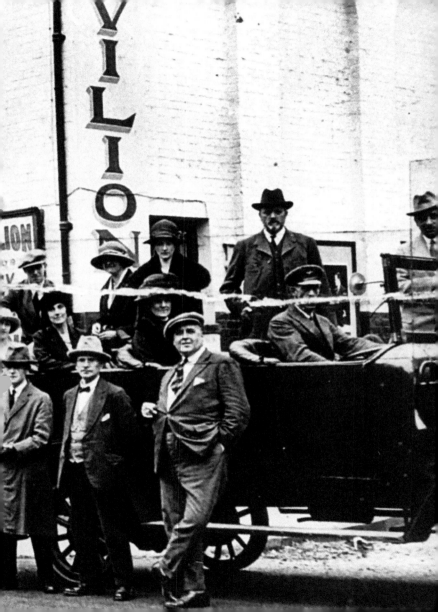

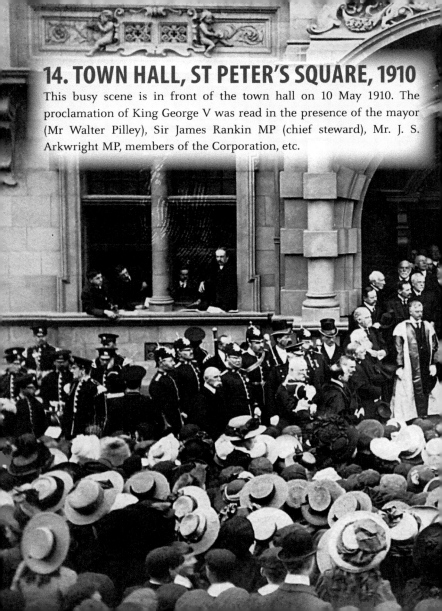

14. TOWN HALL, ST PETER'S SQUARE, 1910

This busy scene is in front of the town hall on 10 May 1910. The proclamation of King George V was read in the presence of the mayor (Mr Walter Pilley), Sir James Rankin MP (chief steward), Mr. J. S. Arkwright MP, members of the Corporation, etc.

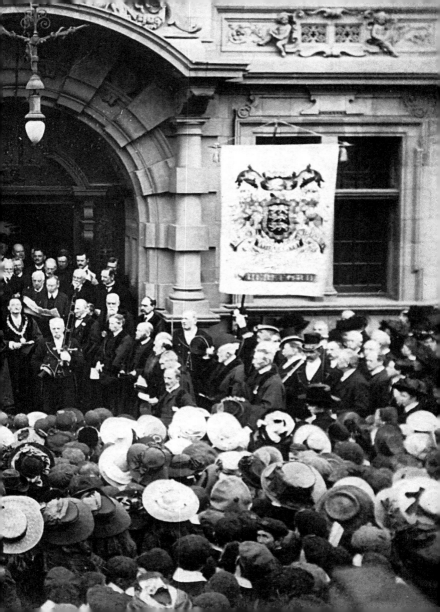

15. SHIRE HALL, ST PETER'S SQUARE

St Peter's Square around the 1930s – the heyday of the bus long before car ownership was widespread. The Shire Hall was erected in 1815 at a cost of £52,000 and opened in 1817. The Hereford War Memorial was unveiled 7 October 1922. The traffic now goes one way from Union Street into the square, but only buses are allowed to drive through to the left of the war memorial.

THE WAR MEMORIAL & SHIRE HALL, HEREFORD.

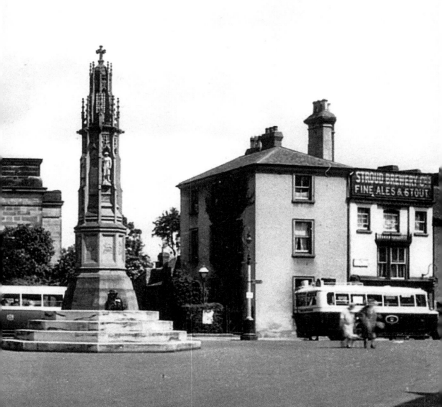

STROUD BREWERY C[o.]
FINE ALES & STOUT

R 22

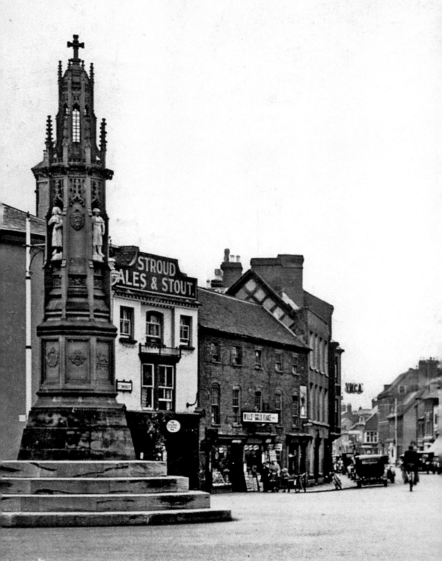

STROUD
ALES & STOUT.

Saint Peters Square

16. ST PETER'S SQUARE TO ST OWEN STREET

The motor cars indicate that the date is around 1937. The town hall had its foundation stone laid by HRH Princess Henry of Battenburg on 13 May 1902, when Edward Bosley was the mayor. The flag pole turret stands stands high above the adjacent buildings.

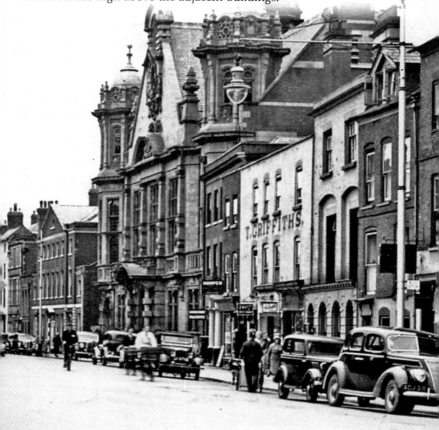

17. REMEMBRANCE DAY, ST PETER'S SQUARE

Following the end of the Great War, the city honoured its dead by erecting a temporary wooden cenotaph in High Town. This is the first service at the new stone memorial in St Peter's Square, which was unveiled 7 October 1922 by Lieutenant Colonel Gilbert Drage DSO and Colonel M. J. Scobie CB of the Herefordshire Regiment. They committed the memorial to the safekeeping of the Corporation. The memorial is in the shape of an Eleanor cross.

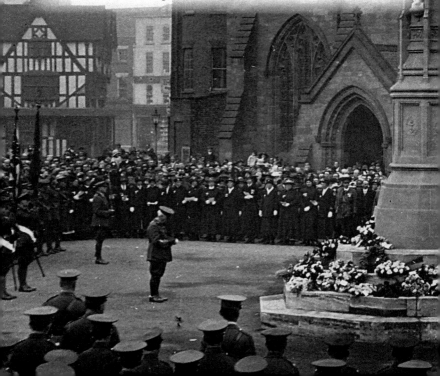

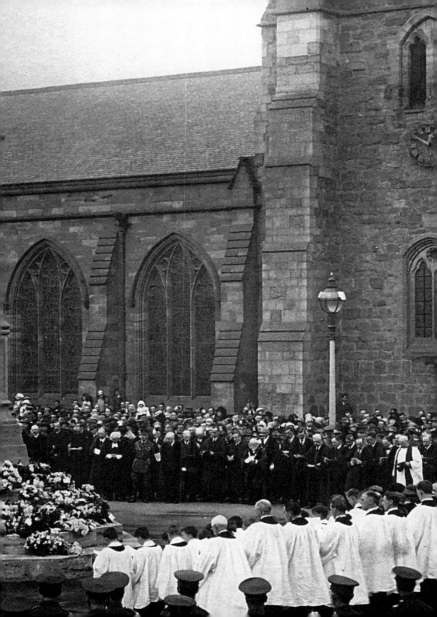

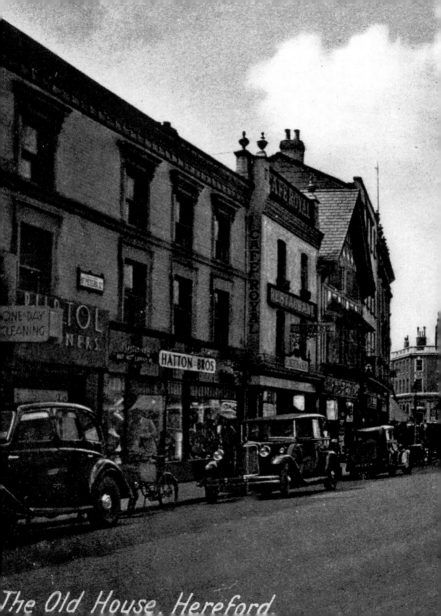

The Old House, Hereford

18. ST PETER'S STREET TO OLD HOUSE

St Peter's Street around 1938; note the parked cars are pointing in both directions. This road went towards Ledbury and Fownhope. In 1928, the Old House was given to the city by Lloyds Bank, who occupied it for over forty years.

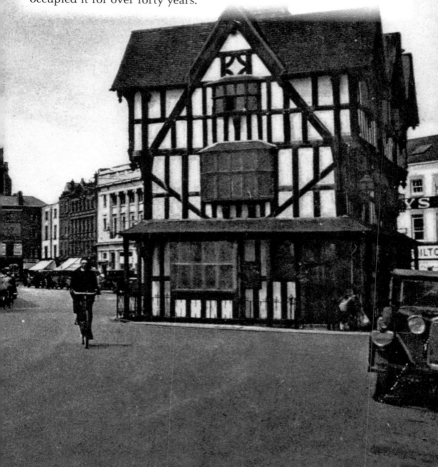

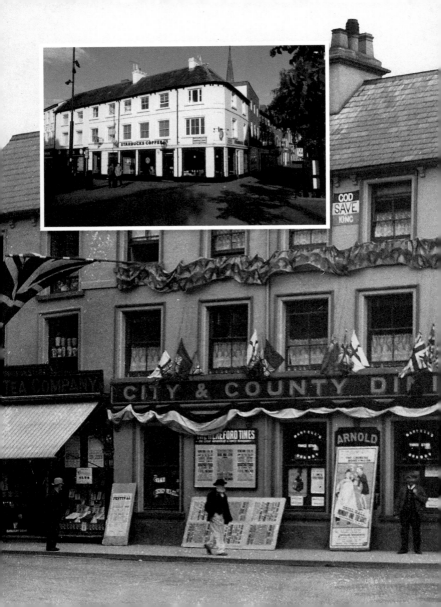

GOD
SAVE
KING

TEA COMPANY

CITY & COUNTY DI

THE HEREFORD TIMES

ARNOLD

STARBUCKS COFFEE

19. THE CITY AND COUNTY DINING ROOMS, HIGH TOWN

Mr Henry Jones was manager here around 1910. He had a prime site in the city centre, facing High Town and the Old House. The banners proclaim 'God Save the King'. The occasion is unknown, but it could be the coronation of King George V. The ladies are wearing full-length costumes. The building was restored by the Cheltenham & Gloucester Building Society and is now a coffee shop.

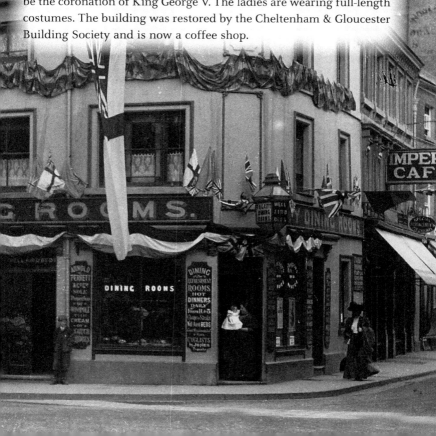

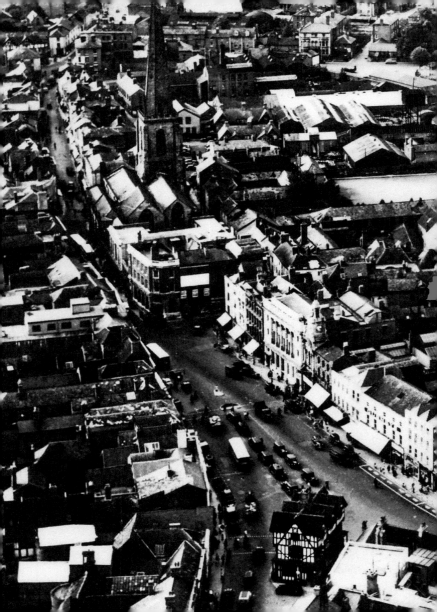

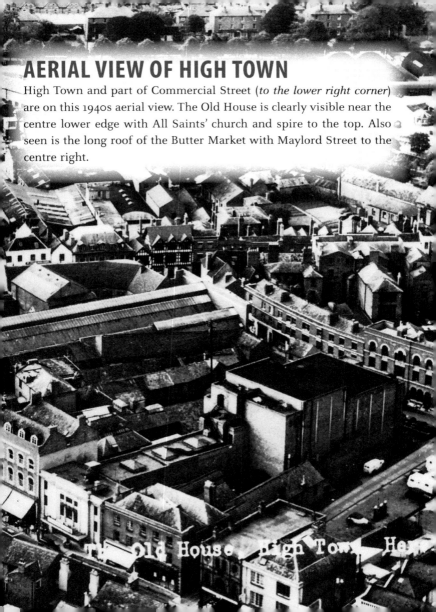

AERIAL VIEW OF HIGH TOWN

High Town and part of Commercial Street (*to the lower right corner*) are on this 1940s aerial view. The Old House is clearly visible near the centre lower edge with All Saints' church and spire to the top. Also seen is the long roof of the Butter Market with Maylord Street to the centre right.

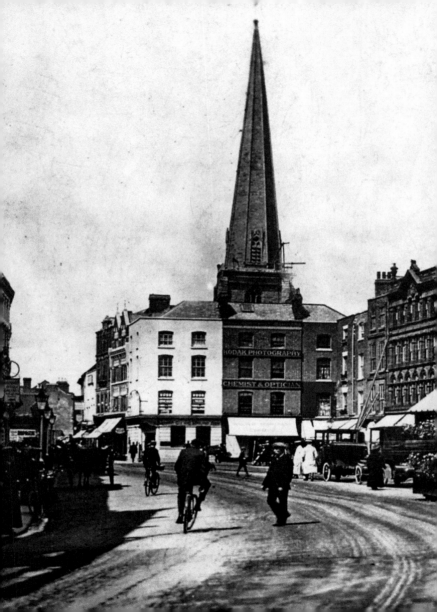

20. HIGH TOWN TO HIGH STREET

High Town around 1920 with the motor taxis awaiting their fares. All Saints' church tower and steeple base are undergoing restoration. The buildings to the left of the Butter Market Hall were demolished in 1928 by Lloyds Bank. The Butter Market entrance and clock tower was opened 10 October 1860. A superb black-and-white half-timbered town hall on wooden pillars stood in the middle of High Town, but it was sadly demolished in 1861. High Town is now a paved pedestrian precinct.

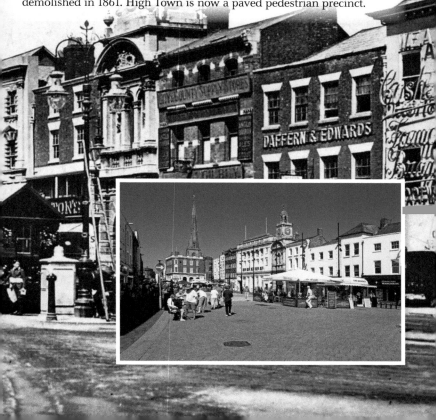

21. HIGH TOWN OLD HOUSE

This must be the second most common picture of Hereford. It is of the Old House, built in 1621. The hut is one of two that were used by the city's cabbies. Judging by the long costumes, the postcard would date from the early years of the twentieth century. The Old House has been restored several times since it was donated to the city by Lloyds bank in 1929. Today it is a museum open to visitors free of charge.

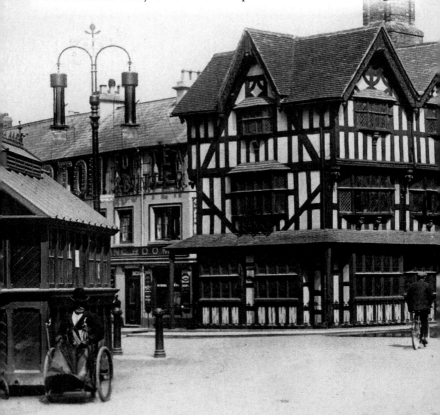

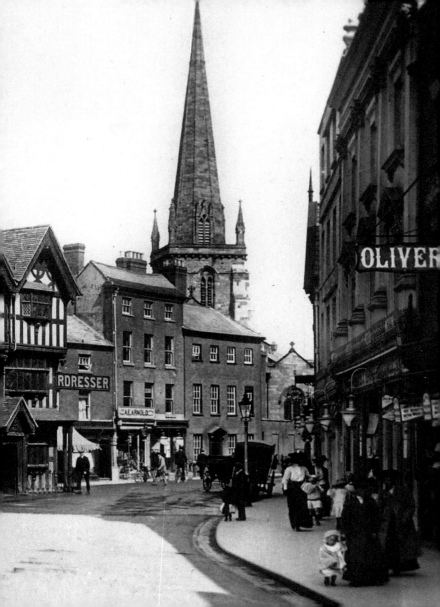

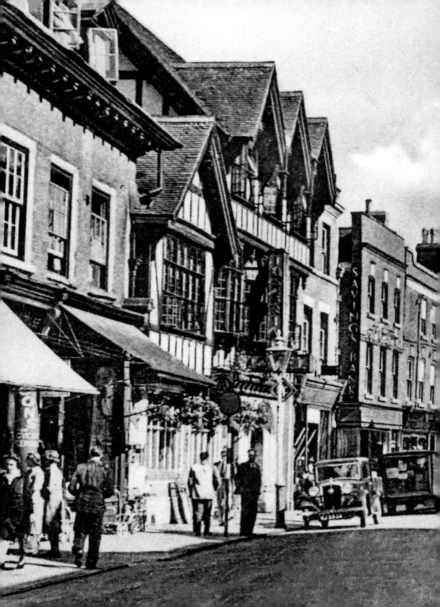

22. WIDEMARSH STREET

Widemarsh Street around 1946 showing traffic travelling in both directions and plenty of space to park. To the left is the Mansion House, which in January 1907 was the Municipal Surveyors, Gas, Water Works and Rates Office. The shop on the left was G. Wright and Son, fruiterers, while to its right was R. J. Jenkins, outfitters. Next door is the Imperial Hotel, which is an early twentieth-century reproduction half-timbered building. Reproduced from an original Frith & Co. postcard.

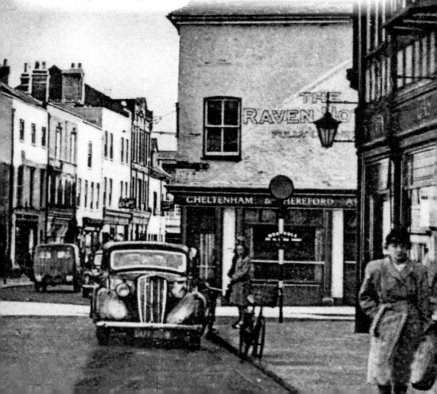

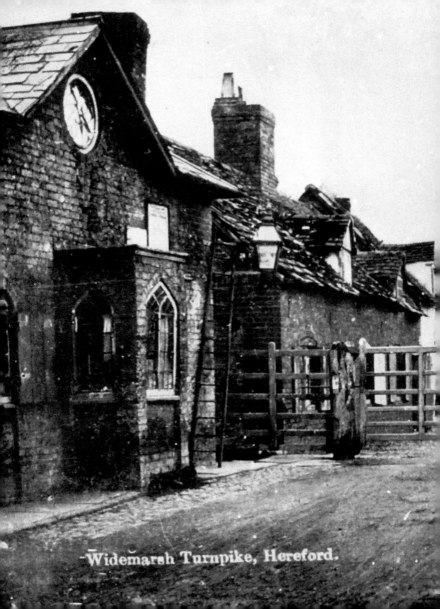

Widemarsh Turnpike, Hereford.

23. WIDEMARSH STREET TOLL GATE

Turnpike gates were established in 1663 where tolls were taken from passengers and vehicles to pay for the upkeep of the roads. They were abolished in 1870. In 1888, the Local Government Act put the responsibility of maintaining main roads on to the county councils. This is Widemarsh Gate where the second building on the left is the Essex Arms, occupied by Mrs Sophie Parry. In the background at Nos 75–78 was Symond's Hospital, founded in 1695 for four persons.

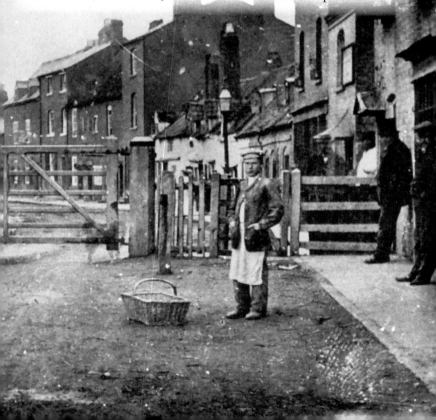

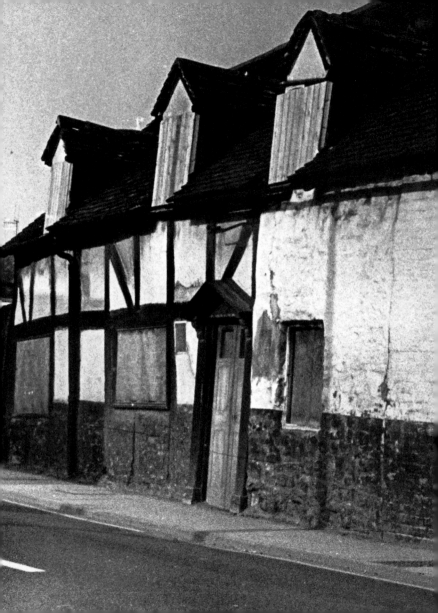

24. THE ESSEX ARMS, WIDEMARSH STREET

The final days (1985) of the Essex Arms, Widemarsh Street, once sold in 1930 for £3,600 to the Stroud Brewery owner Mr A. J. Perrett. The Essex Arms was dismantled and in 1989 rebuilt at Queen's Wood on Dinmore Hill. Though now preserved in a rural environment, this building was a loss to the city.

25. PLOUGH INN, WHITECROSS ROAD

The Old Plough Inn on the corner of Whitecross Road and Plough Lane. The timber-framed coach house is on Plough Lane, which leads to Canon Moor Farm and the Midland Railway Inn. In 1934, it was listed as Ye Old Plough Inn and run by Mrs Rosa Bailey. By 1955, Mr Woodward was the new landlord. On the lane to Canon Moor Farm were Sweetman & Son hauliers, Hereford Petroleum Co. and Asphalt Public Works.

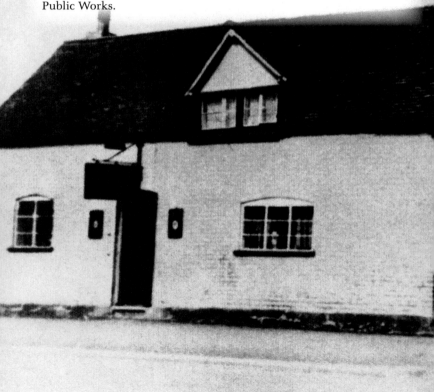

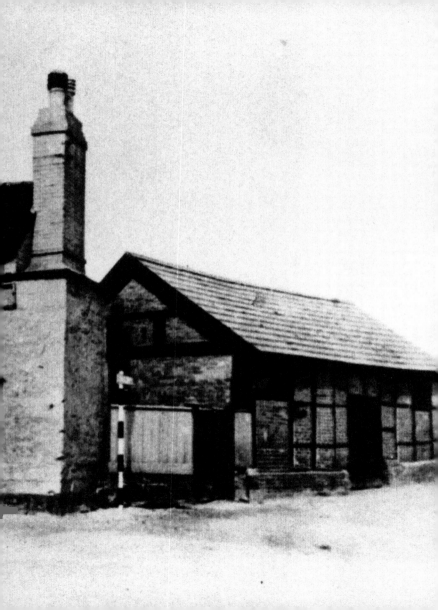

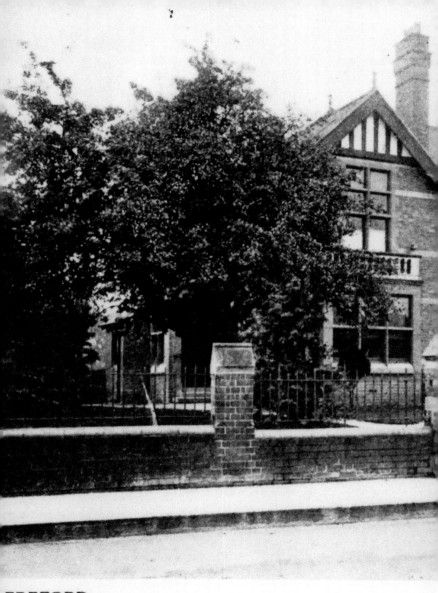

EREFORD

26. EIGN STREET EYE HOSPITAL

The Victoria Eye and Ear Hospital was established under the name Herefordshire and South Wales Eye and Ear Institution in July 1882. This hospital in Eign Street was opened 29 August 1889. This photograph was taken around 1910, when the hospital had beds for 20 patients and 2,000 outpatients were seen each year. Recently, the building was sold and has been converted into apartments.

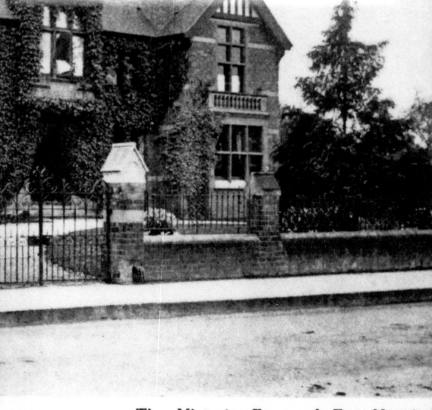

The Victoria Eye and Ear Hospita

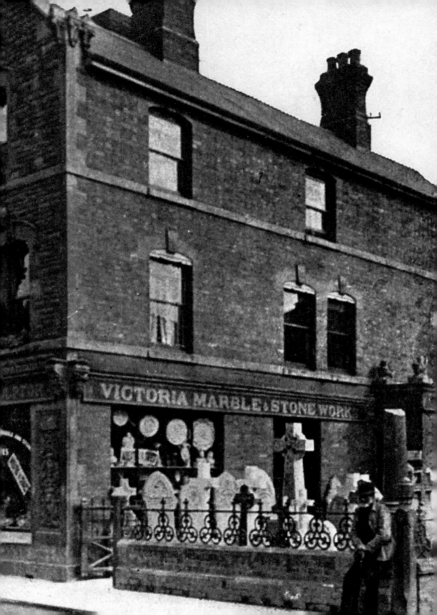

27. KING'S MONUMENTAL MASON, EIGN STREET

This rather grainy Wilson and Phillips postcard of around 1904 clearly shows T. A. King's Victoria Marble and Stone Works and the large yard with stone memorials. They were at the junction of Eign Street and Victoria Street. A 1907 catalogue and photograph for these premises indicates that it had become the Hereford Motor Co. The building was demolished in 1967 to make way for road widening.

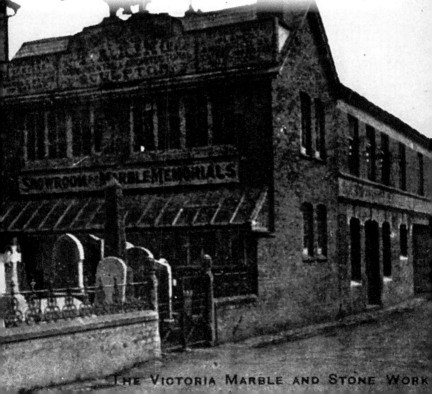

THE VICTORIA MARBLE AND STONE WORK

28. EIGN STREET VIEW WITH FLAGS

Eign Street decorations celebrating the Three Choirs Festival in 1906. The large flags almost form an arch across Eign Street. This view towards the east shows Clarkson's and Stewart's Peoples Stores with a board advertising Gilbey's wines and spirits. Next door is Thackway's, the tobacconist. Seven shops further on is Jennings, a saddler. The street was pedestrianised many years ago and recently refurbished. Of the businesses in the earlier photograph, only Jennings the saddlers survived into the 1990s.

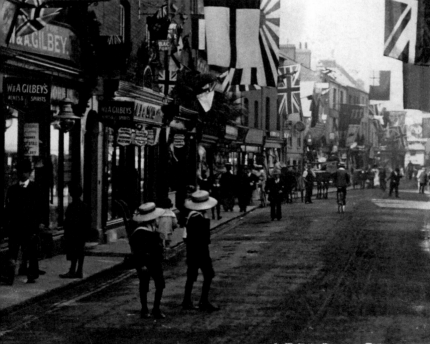

ESTIVAL DECORATIONS HEREFORD 100.
EIGN ST

29. NELSON'S BUTCHERS, EIGN STREET

In 1900, Hereford had over thirty butcher's shops, so the trade was fairly substantial. The old Butter Market had ten butchers. Without refrigeration one wonders how long the meat could be stored. This is Nelson's shop in Eign Street around 1912. Mr Nelson is just visible inside with his sons outside. The whole display is labelled 'Prime New Season's Lamb' and 'fresh supply daily'.

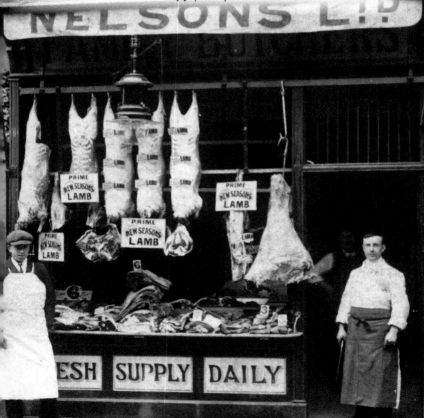

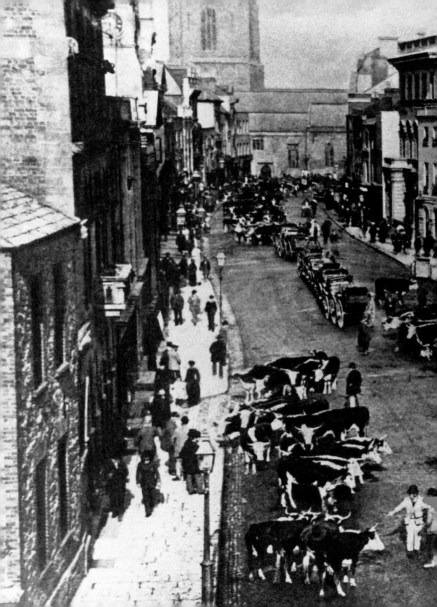

30. BROAD STREET CATTLE MARKET

A cattle fair was held periodically in Broad Street. This photograph dates from the 1880s and around thirty heads of cattle are seen in the foreground, with many more in the distance. In between is a line of some ten horse-drawn 'taxi' cabs. The road surface looks well manured and there are pedestrians on the pavement. Note the newly built post office on the right.

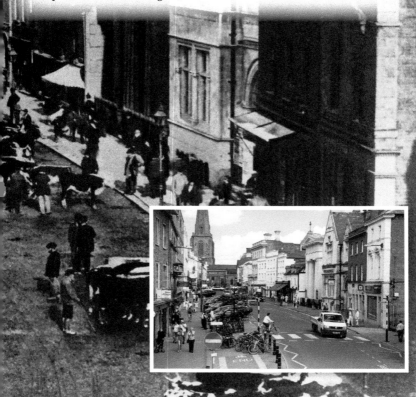

31. KEMBLE THEATRE, BROAD STREET

This fine building, the Kemble Theatre, stood in Broad Street. Originally the Corn Exchange, it had a Bath stone front and clock tower. It was enlarged in 1911 by adding a public hall and theatre at a cost of £5,000, and it seated 1,000. Today the name survives as Kemble House. A proposed heritage wall plaque will read 'Kemble Theatre. The Kemble family, including Sarah Siddons, performed in the first theatre (*c.* 1700). Replaced by Corn Exchange (1857) and Kemble Theatre (1911). Demolished in 1963.'

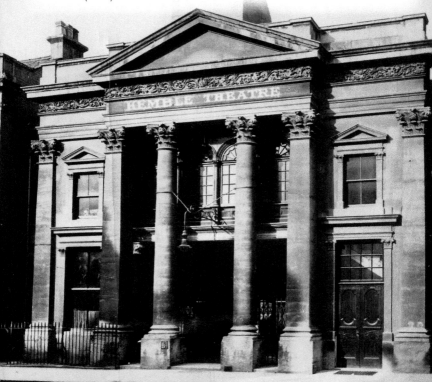

32. BROAD STREET POST OFFICE

The main city post office in Broad Street was opened 20 December 1882 and cost £5,614. It has an interesting stone fascia with some ornate features. Lined up in front are the post office staff with manager Samuel Ilsey. Nine workers are in tunics without a tie and eight with winged collars and ties. Today the building is used as a restaurant but the post box remains in use.

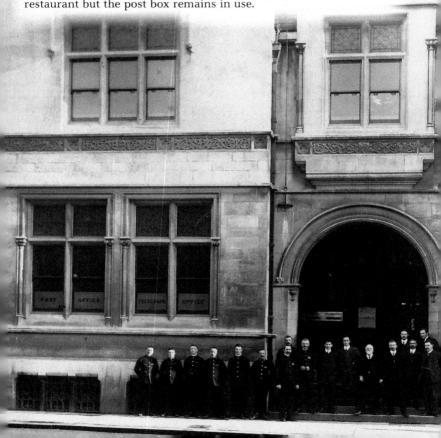

33. KING STREET TO THE CATHEDRAL

Nearly the whole length of King Street is visible on this early 1900s picture. Note the buildings on the Cathedral Close in front of the cathedral. In April 1935, this house and its attached neighbours caught fire while awaiting demolition. The buildings were demolished using funds donated by Col. Haywood of Caradoc Court, thus making the west front of the cathedral visible from Broad Street and King Street.

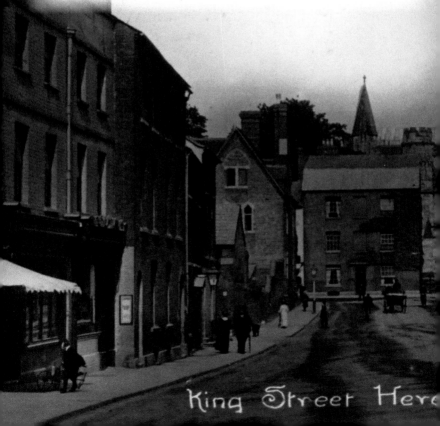

King Street Here

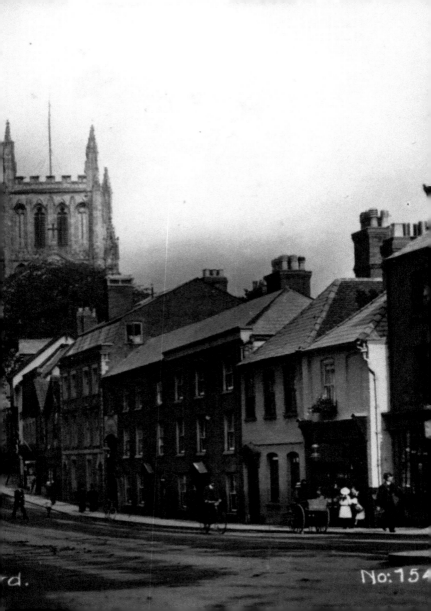

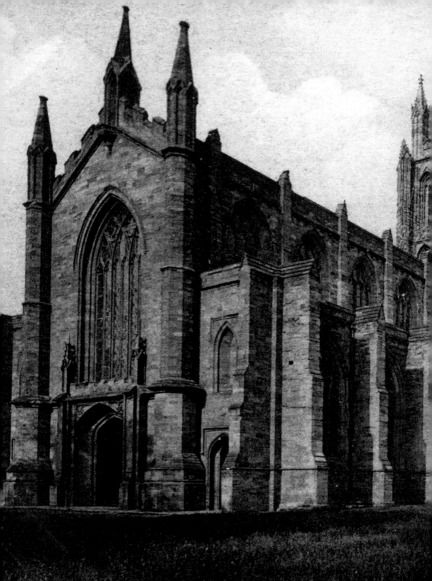

EREFORD CATHEDRAL, FROM

34. HEREFORD CATHEDRAL

Of Norman origin, the cathedral replaced an earlier church that was totally destroyed in 1055 by Welsh invaders. The west end of the cathedral, insecure for many years, collapsed on Easter Monday, 17 April 1786. The dean at that time gave instructions to architect James Wyatt to remove the central tower spire and shorten the cathedral by 15 ft. This shows the old west front by Wyatt. Alterations started around 1902 on the new west front, designed by architect Oldrid Scott at a cost of £15,560.

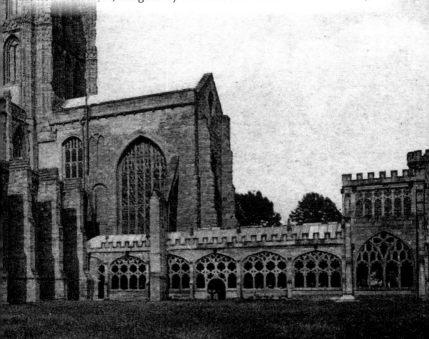

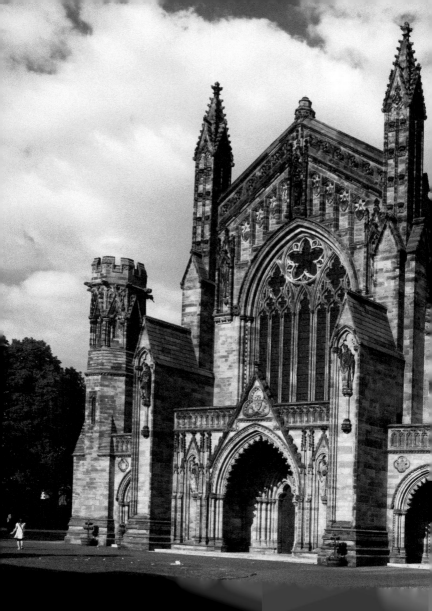

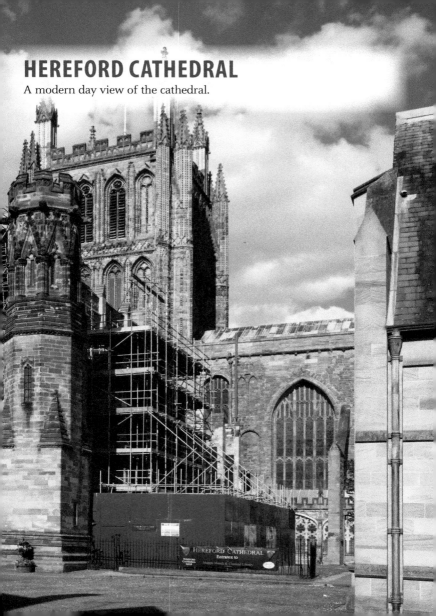

HEREFORD CATHEDRAL

A modern day view of the cathedral.

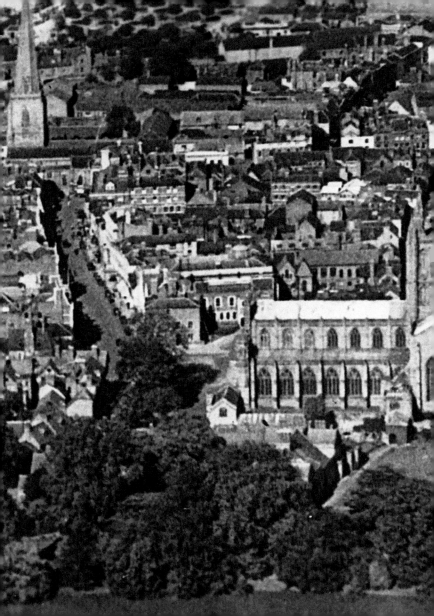

AERIAL VIEW OF HEREFORD CATHEDRAL

Hereford Cathedral has a prominent position on the north bank of the River Wye, with the Bishop's Palace in the foreground and trees along the riverbank in this photograph taken in April 1921. The Lady Chapel seen to the right of the tower looks almost detached. To the left of the cathedral is a view along Broad Street to All Saints' church. The Cathedral Close has recently had a million-pound refurbishment, now completed.

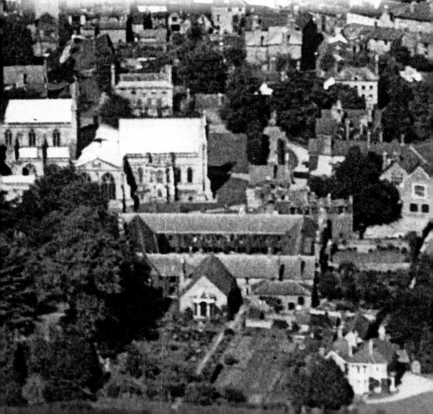

CATHEDRAL TOWER TO ALL SAINTS' CHURCH

An unusual view from the top of the cathedral tower, along Broad Street (on the left) and with All Saints' church in the centre. The dome is on St Francis Xavier's church roof. The gasworks at Mortimer Road, which opened in 1873, are visible to the right of centre.

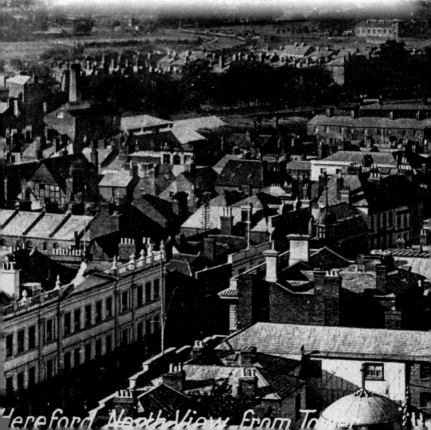

Hereford North View from Tower

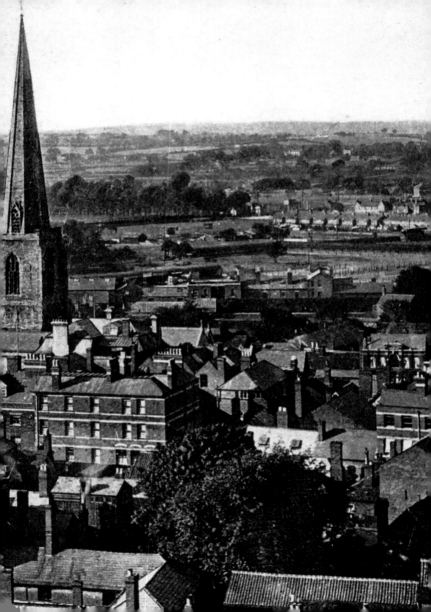

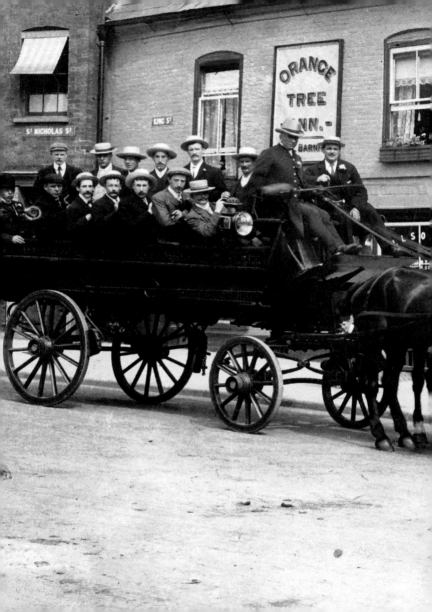

35. THE ORANGE TREE, KING STREET

This superb picture from the turn of the century features four horses wearing their fine display of brass and the brake wagon with fifteen seated male passengers. The landlord at the time was George Barnham. The door on the right is the entrance into the photographer's studio Ladmore and Son.

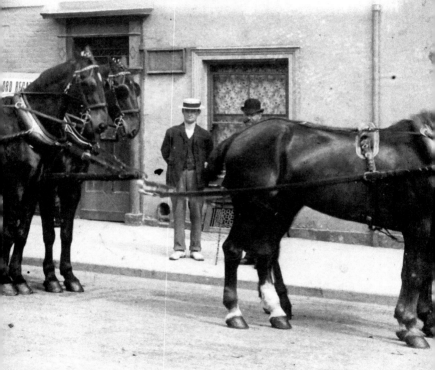

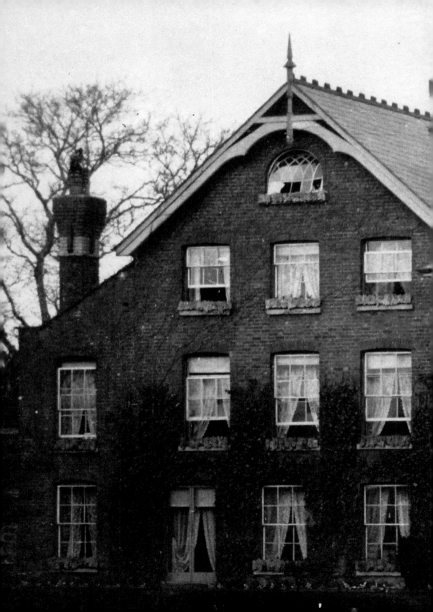

36. THE FRIARS, GREYFRIARS AVENUE

This large house, The Friars, dates from early Victorian times and stands on the riverbank, 200 yards upstream from the old Wye Bridge. Nearby is the lost site of the Grey Friars' monastery. Around seventy years ago, during excavations for a new house in Greyfriars Avenue, some human remains were found. They are thought to be from the burial ground attached to the monastery. This house was once the Greyfriars Restaurant, which closed down many years ago and has since become derelict and now demolished.

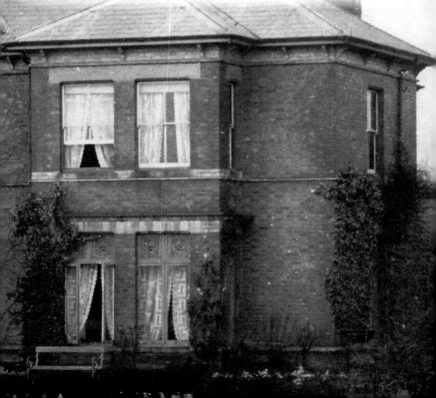

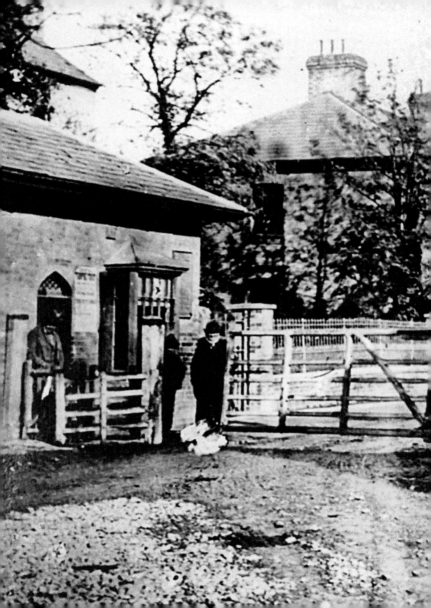

37. ST MARTIN'S TOLL GATE

Hereford had several turnpikes, which were removed in 1870 when they were abolished. This picture of St Martin's would date before 1869. The turnpike keeper collected the tolls that went towards the upkeep of the highway. His chickens run on the road searching for food. Note how the gas lamp is positioned to illuminate the area and ensure that people could not pass without payment. The inset image shows the area in 2009 – what a transformation!

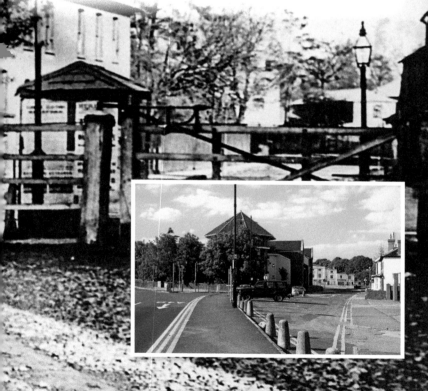

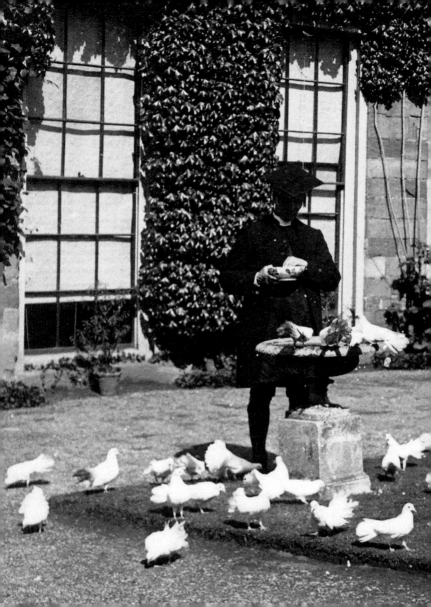

38. BISHOP'S PALACE

This is Bishop Percival [Bishop 1895–1915] in the palace gardens with his doves. These gardens may have been the site of the Saxon cathedral. The building behind the bishop is his palace, which contains some very early timbers and has long been recognised as being one of the most important Norman secular buildings in England (dated *c.* 1185).

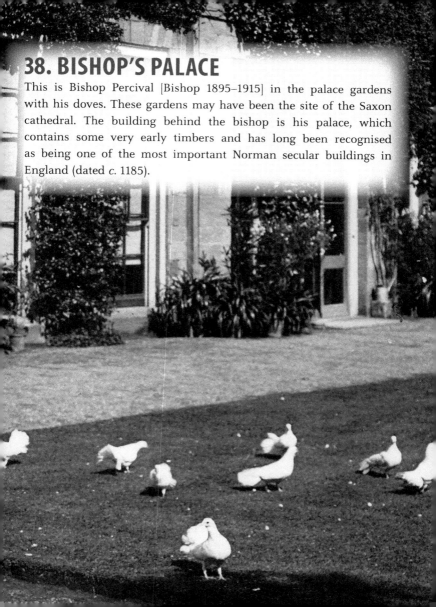

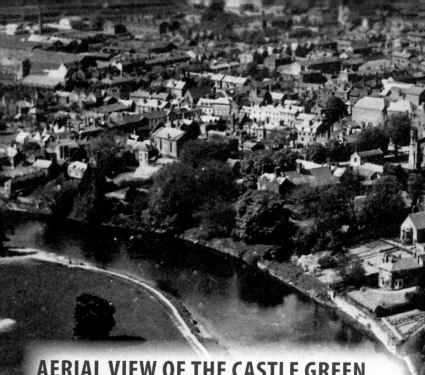

AERIAL VIEW OF THE CASTLE GREEN AND VICTORIA BRIDGE

Early aerial photographs of Hereford are of special interest. This is the River Wye, Castle Green, Victoria Bridge and cathedral taken around 1920. The Bishops Meadow is grazing land with parch marks and the Castle Green is surrounded by trees. Virtually the whole of the city centre is visible. The bowling green (on the Castle Green) is only just defined and has no visible protective fence. It was opened in 1908 by Councillor J. Mitchell.

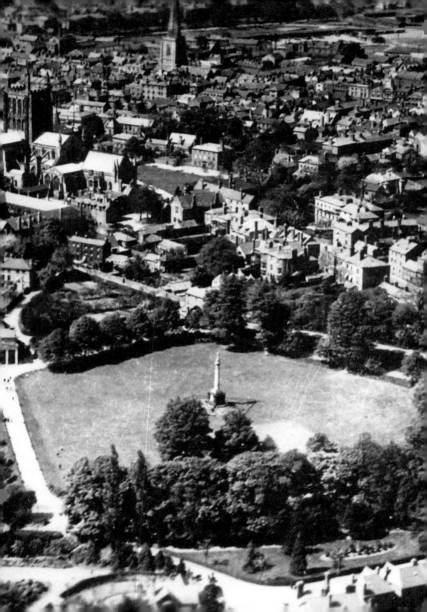

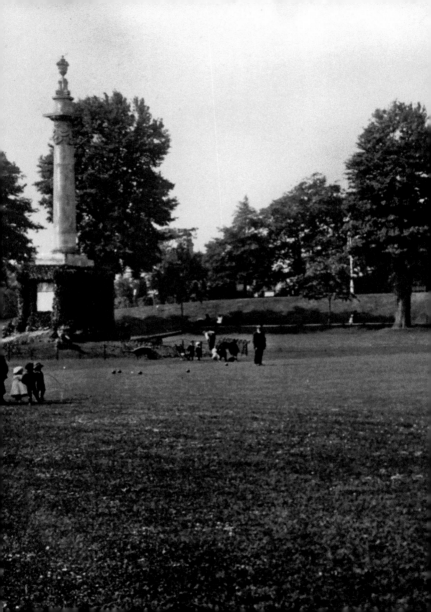

39. CASTLE GREEN AND NELSON'S MONUMENT

Castle Green, on the site of Hereford Castle, was a popular spot in Victorian and Edwardian times. The City Corporation Parks Department have recently planted trees on the far side. The green was first used as a public park in 1753. Nelson's column, 60 ft high and erected in 1809, commemorates Lord Nelson, who was killed at Trafalgar in 1805. Note the cannons at the foot of the Nelson Monument.

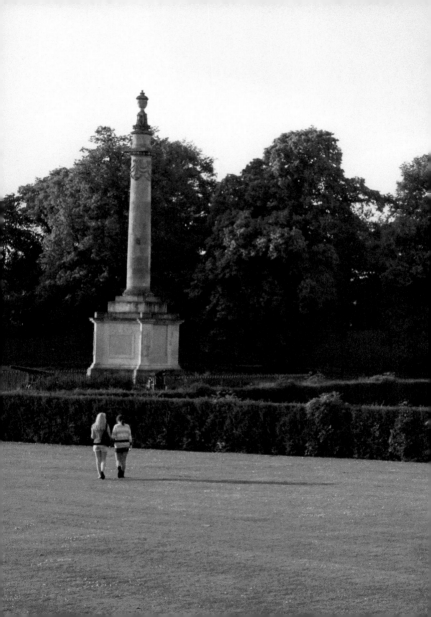

CASTLE GREEN AND NELSON'S MONUMENT

A present-day view of the monument on Castle Green.

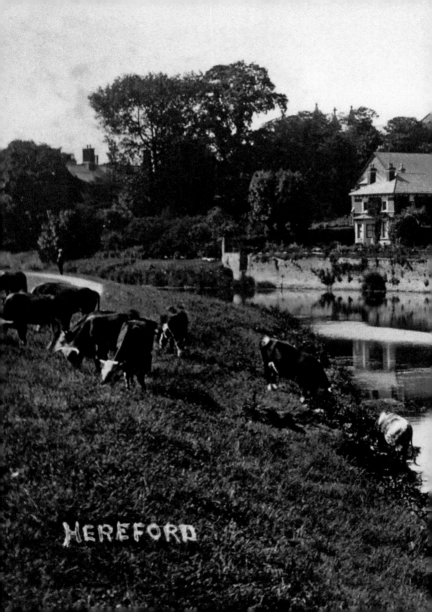

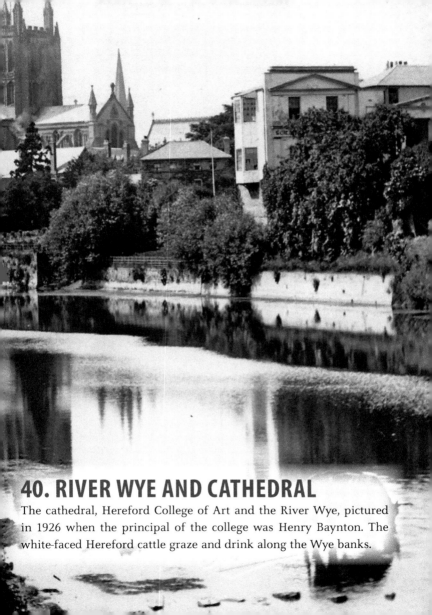

40. RIVER WYE AND CATHEDRAL

The cathedral, Hereford College of Art and the River Wye, pictured in 1926 when the principal of the college was Henry Baynton. The white-faced Hereford cattle graze and drink along the Wye banks.

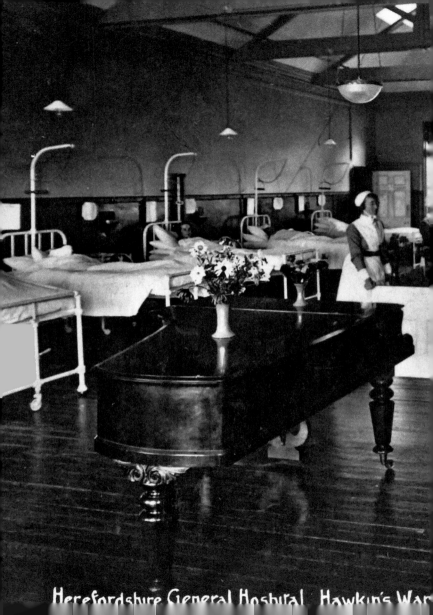

Herefordshire General Hospital, Hawkin's War

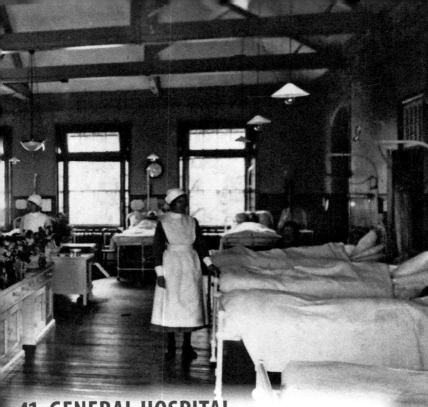

41. GENERAL HOSPITAL

The Hereford Infirmary, photographed in 1910. This building dates back to March 1776 and was built on land donated by the Earl of Oxford. The founder of the Hereford General Infirmary was the Revd Thomas Talbot of Ullingswick. In 1928, it was reported that there were eleven wards and two isolation wards. The hospital could accommodate 125 patients (fifty male, fifty female and twenty-five children). It was supported by subscriptions. The old hospital is now closed and converted into apartments.